Restoring Oil Paintings — a practical guide

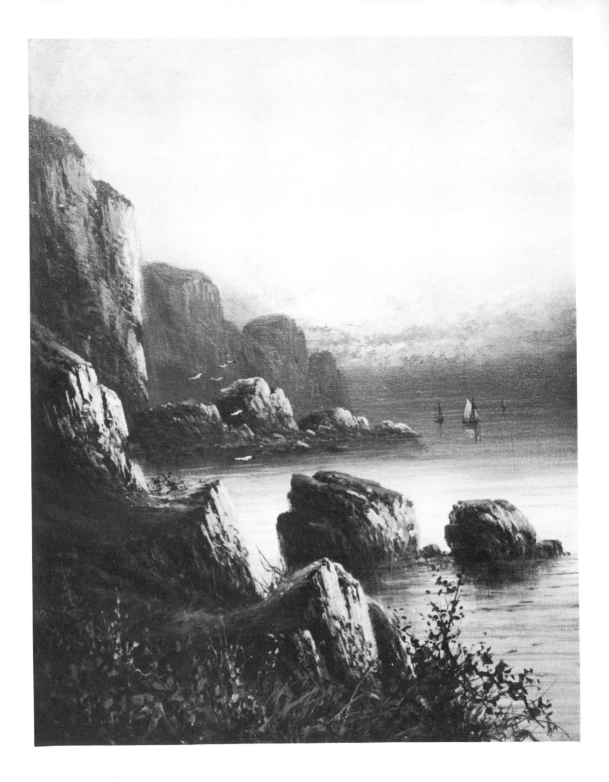

Restoring
Oil Paintings
— a practical guide

Tim Aldridge

Bishopsgate Press Ltd
37 Union Street, London SE1 1SE

Frontispiece. The painting restored by the author, and shown in this book, in its finished state.

Illustration 42 Courtesy of Christies South Kensington.

ISBN 0 900873 60 4 (case)

0 900873 62 0 (limp)

All enquiries and requests relevant to this title should be sent to the publisher, Bishopsgate Press Ltd., 37 Union Street, London SE1 1SE

Printed by Whitstable Litho Ltd., Millstrood Road, Whitstable, Kent.

Contents

Introduction

The art of **good** picture restoring is a skilled accomplishment, often incorporating many years of intensive study, a deep knowledge of the chemicals involved in professional restoration and, possibly above all, experience.

Even then the restoration of 'Old Masters' frequently necessitates consultation between experts, for there is always more to learn and other restorers' individual knowledge and techniques in certain areas may be greater than one's own.

This book then is intended merely to guide the amateur picture restorer along fairly safe lines, so that, armed with the knowledge that 'experience counts' and that damage can be irreparably done to a painting by (a) lack of knowledge, of experience and of care and (b) by using the wrong materials or the misuse of the right materials, usually again due to a lack of experience, he or she will be more aware of what can or cannot be done.

It was once the author's 'privilege' to watch, with astonished horror, the 'restoration' of an oil painting which included surface cleaning with brisk sweeping rubs of a large pad of cotton-wool saturated with a mixture of Vim and washing up liquid. This did indeed remove, scour is perhaps the better word, the old varnish. It also removed considerable amounts of the painting and the nonchalant manner with which swabs, liberally coated with paint, were tossed on one side, only to be replaced with fresh swabs so the process could be repeated, left one feeling quite weak.

The first important thing for the amateur restorer to do is to check that the picture they wish to work on is of little or no value. Unless you are quite certain that this is the case you can usually ascertain the painting's value through most reputable auction rooms. Several major London auction rooms, for instance, have desks where anything can be taken for an opinion.

If you know, or discover, that your painting has some, albeit even small value, you must consider whether you are prepared to risk damaging the painting by working on it yourself. If it is a fairly valuable work, or has great sentimental value, then it is recommended that the picture is taken to a professional restorer for proper treatment.

1. A fine painting by A. M. Burton dated 1926 already showing signs of flaking along the base.

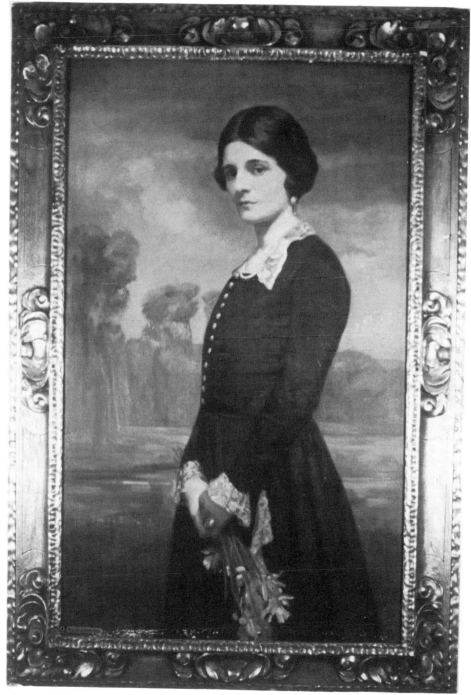

1

Showing the painting to an expert for financial assessment is a useful exercise. The author has often been shown pictures by a proud owner who has stated something like 'Granny said I would have this when she was gone and to look after it as it is (or will be) worth a lot'. In most instances one has to gently break the news that Granny was, to be diplomatic, herself mis-informed or just hopeful

It has, to be fair, happened the other way round; with paintings brought in quite casually for 'a bit of a clean', one has been able to tell the owner that the picture, often 'found' in their or their relative's attics, is worth hundreds or even thousands of pounds.

Do's and Dont's

Do . . . Have your painting checked for value before working on it yourself.

Inspect it carefully before commencing work on it.

Take it slowly, especially at the cleaning stage.

When using chemicals, work with adequate ventilation, away from naked flame, and wear protective gloves.

Remember that various colours re-act differently and whilst one colour may not be affected by the cleaning solvents, the next colour could be completely or partly removed by them.

Don't . . . Use water, or soap and water to clean pictures.

Use detergents or washing up liquid to clean pictures.

Rub the picture surface hard with your cotton-wool swab whilst cleaning.

2. *The author at work.*

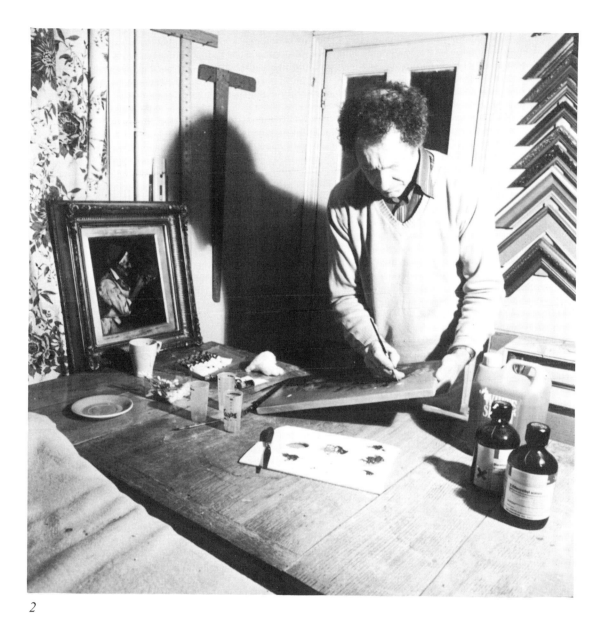

2

General Equipment

1. **Strong Lighting Source**
 It is recommended that, if good daylight is not available, then a clear light bulb of, preferably, 500 watts should be used. If you can use fluorescent lighting this is better, but it is important to use 'Colour Matching' tubes or their equivalent. Ideally a double tube unit should be used but unless you are likely to be restoring a number of paintings it is not practical to invest too much money into equipment which has no other use.

2. **Cotton Wool**
 Both in rolls and sticks (or buds), this is used in quantity throughout the various cleaning processes.

3. **Protective Gloves**
 Some people's skin reacts even to white spirit let alone the more powerful chemical solvents used. These latter chemicals can also take the colour out of the usual household rubber gloves. It is therefore necessary to obtain either colourless surgical gloves (obtainable from bigger chemists) or white or clear household gloves.

4. An old strong cardboard box, or heavy plastic waste tub for your used wool swabs.

3. General view of part of the author's workroom.

10

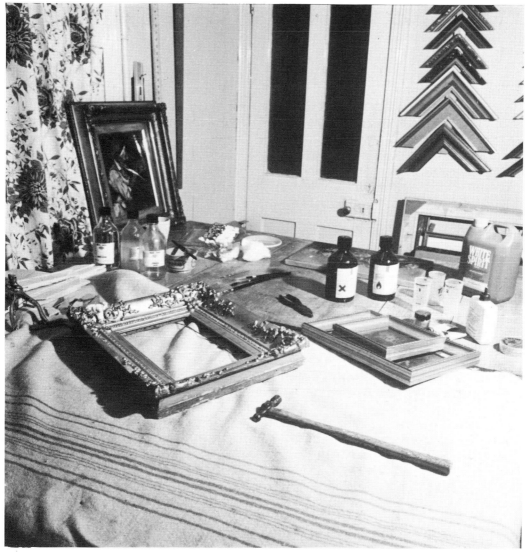

3

Inspecting the Painting

Once again, without belabouring the point, only tuition and experience will enable you to recognise and identify the problems and decide how to deal with them properly. Even so you will find that a good look at the painting under a strong light, both with a good magnifying glass and the naked eye, will be worthwhile

You should observe how even the old varnish is. If it covers the whole surface of the painting it is most probable that any of the muck of time is on the varnish and not on the actual paint. Any really dull areas indicates the possibility of little or no varnish (old paintings, usually by amateur artists, were frequently not, or were inadequately, varnished). This means that decades of dirt have solidified on the paint surface and will probably be difficult or impossible to remove without disturbing this surface.

Look for previous restoration. This is often apparent in the sometimes subtle, even obvious, change in colour from the original; in the difference of the technique, i.e. brush strokes etc, between the restorer's work and that of the original artist's; and perhaps where a smooth paint suddenly interrupts the continuous lines of cracking in the original paint. It is common for restorers, especially when working on less valuable paintings, to cover imperfections by means of adding, say, a cloud to a sky or a branch to a tree or extending some detail in the picture. This addition, being a more recent layer of paint, is likely to come off when you are cleaning the painting and you will have to decide whether to replace it or, if you are capable enough, cover the imperfection by matching, exactly, the surrounding area.

Check cracking of the paint surface very carefully. If any of the paint is lifting at the crack (illustration 4) this should be re-attached to the canvas before the painting is cleaned. Flaking paint should be dealt with at this stage also (see Step 3).

A dark looking painting is **not** necessarily very dirty. Whilst many of the varnishes used in the 19th and early 20th Century yellowed and decades of household dust, nicotine etc. add to the general discolouration, the artists of the day used many browns and

4. *Line diagrams showing lifting and flaking paint*

FLAKING PAINT

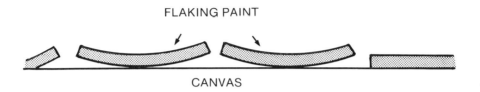

CANVAS

LIFTING PAINT

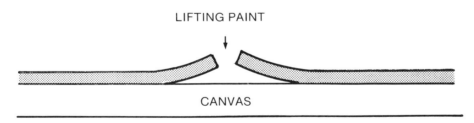

CANVAS

other dark colours in their pictures, and therefore the painting may be naturally dark. Many of the pigments used also discoloured over a period of time. It is easy for the amateur restorer to rub away believing that they are still removing dirt and varnish when they are actually removing dark paint. A reminder . . . constant checking of your swab for traces of paint is essential.

Inspection of the back of the canvas will provide useful information to the observant. Any patching is likely to indicate the quality of previous restoration. If the filling in and re-painting over the patch is unnoticeable from the front then the work is probably of a high standard and should not be disturbed unless there is no option. If the restoration is obvious from the front then you may have to remove the patch and start again. If the entire canvas has a brittle and dry feel and the lines of the cracking paint are visible from the rear then complete re-lining is probably necessary. Extensive paint flaking or lifting makes re-lining essential.

Observation by touch and eye along the surface of the painting over the wooden stretchers will reveal any hard particles of dirt or paint that have become wedged between them and are causing bumps in the canvas (see Step 2).

The close inspection of your painting may have the added bonus of making those of you, who have not previously appreciated the art of the painter and their ability to present a subject in a pleasing manner, to now do so and thus enjoy more the great pleasure that good antique and modern paintings can give. There are those who look and see and those who do not.

5. Checking for lumps of dirt etc. between the canvas and the stretcher bars before cleaning or patching (step 2).

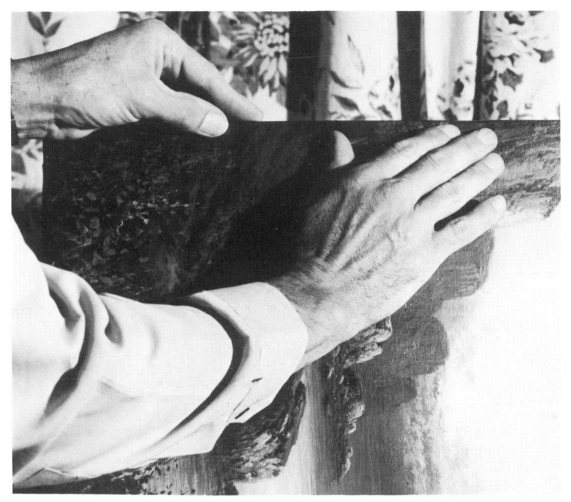

5

Before Cleaning or Patching

Materials

Angled handle painting knife or any very flexible bladed knife.
Large headed tacks
Spare wedges
Hammer (small head)
Stretcher bars (as required)

Check for hard particles, old wedges and lumpy dirt which has become wedged between the canvas and wooden stretchers. You should do this by feeling and looking at the painting's surface above the stretchers (illustration 5).

Remove any such particles with a fine bladed knife, a painting knife with an angled handle is ideal (illustration 6).

Make sure the stretchers are in good condition, ensuring there is no active woodworm, that the corner joints are solid and unbroken and that all the 8 wedges (2 per corner) are present. If necessary replace the stretchers and/or wedges.

Ensure that the tacks holding the canvas on the stretchers are secure. Canvas can deteriorate so that it pulls away from the tack head in which case fresh tacks or staples must be applied to firm areas of canvas. Take care to maintain the tension of the canvas by pulling it tight across the stretcher at the point of inserting the new tack or staple (illustration 7).

6. *Removing loose particles from between the canvas and the stretcher bars.*

7. *Replacing a loose tack into good canvas.*

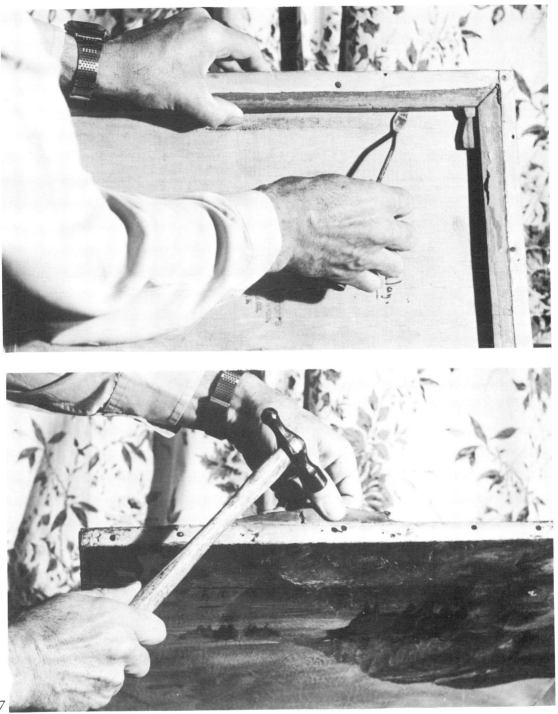

6

7

Holes, Tears, Cracking and Flaking

Materials

Beeswax
Dammar resin
Venice turpentine
Metal pot
Spoon with smooth curved wide handle end
Formica (or thick plate glass)
Brush for applying beeswax mixture (flat hog or bristle brush — not nylon)
Brown paper (thick)
Thin Canvas for patching
Canvas for re-lining (fairly stiff)
Contact adhesive
Electric Iron (which should be kept solely for this purpose in future)
Wallpaper paste (heavy duty) with fungicide
Craft tool or surgical knife with sharp flat or curved blade
Brummer stopping
Cryla texture paste
Flexible bladed painting knife

Provided there is no excessive paint flaking or lifting these repairs can be made either before or after cleaning the painting. If the hole, holes, or tears are small and few they can usually be satisfactorily patched or mended.

8. Showing a typically shaped large tear which can be repaired with a patch.

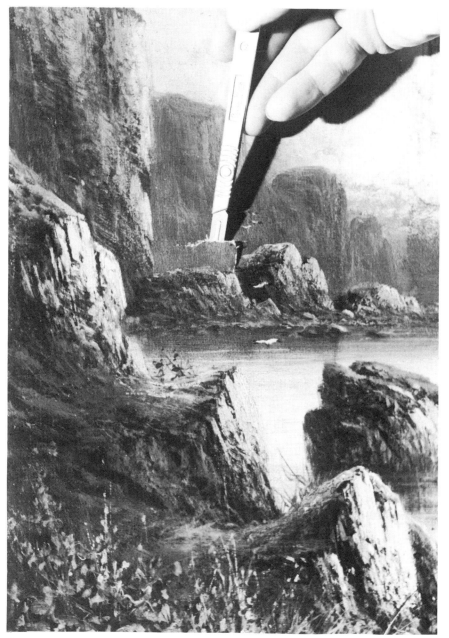

8

Small Tears

There are two methods of mending tears that can easily be used by the amateur. The first is favoured by the author as, if necessary, the mend can later be remade whereas the second method is permanent and, if badly done, can look almost as bad as the original tear.

The first method should always be used on more valuable paintings. Melt together in a suitable pot, 5 parts of Beeswax, 5 parts of Dammar Resin and 1 part of Venice turpentine. Melt slowly and remove immediately it becomes fluid. Replacing onto heat source periodically to maintain consistency.

Take care as this mixture is inflammable

Place the canvas face down on a hard surface (Formica or thick glass is suitable). Ensure the edges of the tear are together and that any odd canvas strands are removed. Drip the mixture over the tear covering it and the surrounding area (illustration 9).

Rub gently over the waxed area with the warm handle of a spoon (hot enough to re-melt the mixture). Ensure the mixture sinks into the back of the canvas. Allow a few minutes to dry before removing any excess of the mixture from the surface of the painting, leaving it smooth and ready for re-painting (illustration 10).

The second method of mending tears is by using a contact adhesive. Place the painting face down on a hard surface and remove stray canvas strands as before. Coat edges of tear with adhesive and press together, place a piece of brown wrapping paper over the tear and keep flat with a weight. When dry remove the weight and brown paper. Take care not to use excessive glue as when dry it will be difficult to remove the paper from the canvas or even the painting from the hard surface it is lying on!

9. *Dripping the beeswax mixture onto the back of the canvas.*

10. *Using a warm spoon handle to work the mixture into the canvas.*

9

10

Holes and Large Tears

Patching is an easier and cheaper alternative to re-lining the entire canvas. It is, however, usually less used by professionals as, over a period of time, the outline of a patch generally becomes apparent. In most cases anyway an older canvas on which paint is cracking is, more often than not, in an overall poor condition and would benefit from a complete re-lining.

If you have decided to patch, prepare the painting as mentioned previously. Spread, with a stiff brush, the beeswax mixture over the back of the canvas covering a slightly larger area than the size of the patch. Coat the patch, which should be cut from a fine canvas such as a tailor's interfacing canvas (illustration 11).

Place the patch over the hole or crack and press lightly with a warm iron until the mixture dissolves, soaks into the original canvas and bonds both pieces of canvas together. **Do not** apply too much pressure as this will cause the outline of the patch to appear on the painting's surface (illustrations 12 and 13).

Remove surplus mixture from the surface of the painting.

11. Coating the patch and torn area of the canvas with the beeswax mixture.

12. Ironing the patch onto the back of the painting.

13. The completed patch.

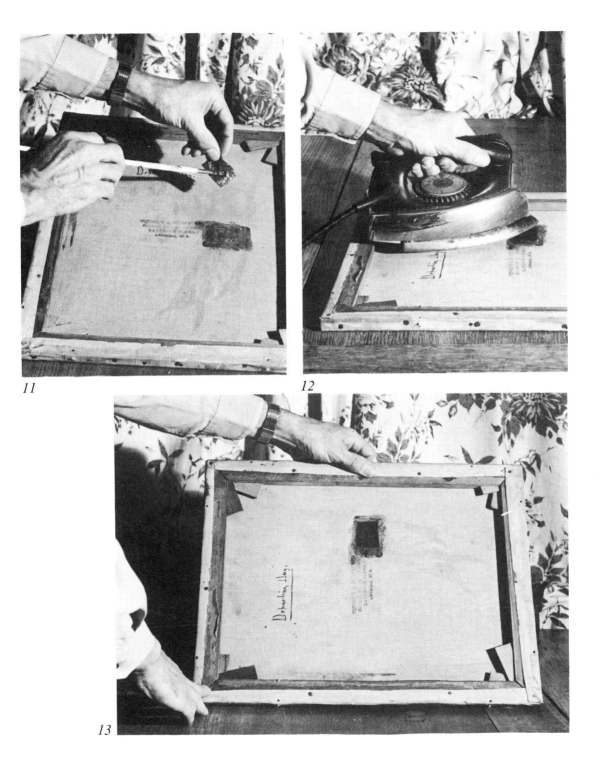

11

12

13

Minor Flaking and Lifting Cracked Paint

It is best to deal with this **before** cleaning the painting as the use of cleaning liquids could otherwise accelerate the flaking or lifting.

Small areas where paint is lifting off the canvas (illustration 4) can be cured with an application of beeswax mixture over the appropriate area on the back of the canvas, and pressing with a warmed spoon handle on the canvas back helps to soak the mixture into the canvas. Then, with the back of the canvas supported by a firm surface, run the warmed and clean spoon handle over the lifting paint until it is merged with the canvas (illustration 14).

If you have any pieces of paint that have become completely detached from the canvas they can be repositioned using the above method. A light coating of the mixture on the back of the paint may be required but the advisability of this depends on the fragility of the paint.

14. With the canvas firmly supported at the back a warmed spoon handle is carefully used to press loose paint onto the canvas

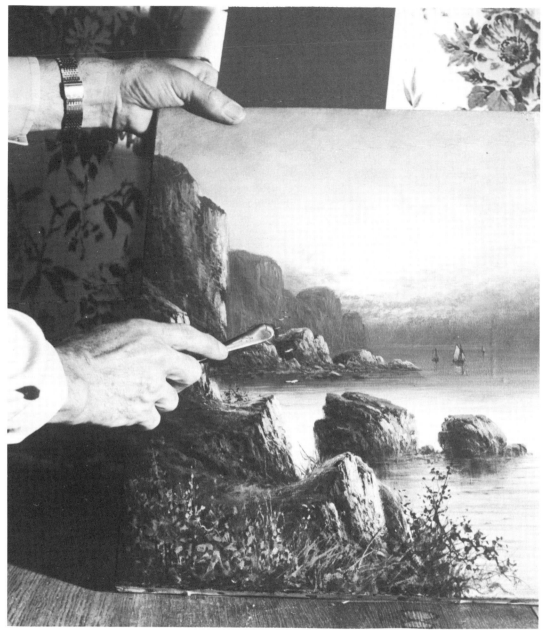

14

Major Flaking, Lifting, Cracking and Holes

If this covers a large area a complete re-lining of the old canvas may be the answer. This entails the cutting of the old canvas around the edges of the painted area and bonding it to a new canvas. If major flaking or lifting is occurring then it is better to re-line before cleaning and restoring the painting. There are specialist firms offering this service to the restorer (check your Yellow Pages under Restorers, Picture Liners etc.). The equipment they use for the proper hot wax processes is not practical for use by the amateur restorer. The method used by the specialist reliner is nearer to the first method described below than the second method, which is only recommended for paintings of little value.

Method 1

Cut out new, stiffish, canvas about 2 to 3 inches per edge larger than your trimmed painting. Apply a thin even coat of the Beeswax mixture to one side or the new canvas and to the back of the painting (illustration 15).

With the painting face down on a hard surface, cover it with the waxed side of the new canvas and lightly press with warm iron until mixture melts and bonds both pieces of canvas together (illustration 16).

Repeat the ironing on the front painted area of the original canvas, pressing lightly through a sheet of brown paper and taking great care not to allow the warm iron to affect the surface of the paint (illustration 17).

Remove surplus wax from the surface of painting leaving it level with the original paint.

15. The new canvas about to be coated with the beeswax mixture.

16. Ironing the new lining canvas onto the back of the original canvas.

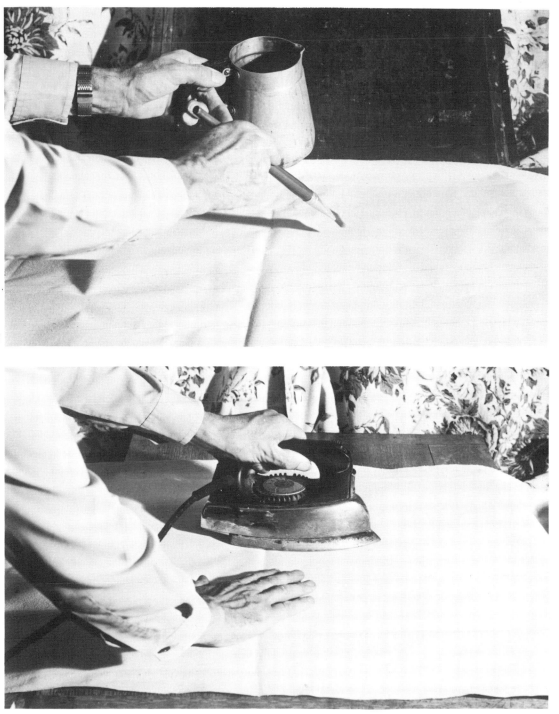

15

16

Method 2

Use a heavy duty wallpaper paste containing a fungicide, coat one or both surfaces as in method 1 with the paste. Bring together the two pieces of canvas and press under weights until the paste is dry.

 Before relining any painting old patches must be removed. The ease of removal will obviously depend on the adhesive originally used. If waxes were used a warm iron will easily remove them. If a glue has been used it may be necessary to use a sharp knife, taking the greatest care not to damage the painting.

17. Ironing the surface of the old canvas through a sheet of stout brown paper to finish the relining process.

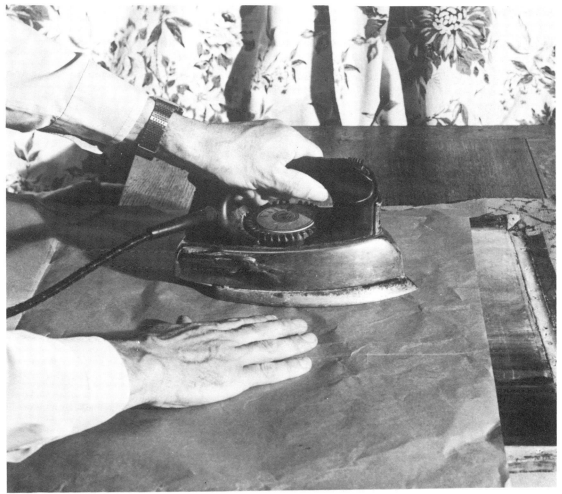

17

Filling Holes and Cracks

Cracking of the layer of oil paint is not normally considered offensive and on a valuable painting it is usually left alone. It is, after all, consistent with the age of a painting and the filling or over-painting of cracks, especially if they are extensive, may well look worse than the cracking itself.

Holes however, must clearly be filled in. The filling can be done before or after the cleaning of the painting. At the latter stage there is the advantage of being able to see more clearly where you need to fill. Also you will be able to see more clearly the surface texture and colour you will need to match. Where the hole is through the canvas obviously the canvas must be patched or relined before the hole is filled. When the 'hole' is simply a piece of missing paint the area may just be filled to the paint level with the selected filler or with new paint (depending on the thickness of the old paint).

Fillers are numerous, the amateur can use putty, which has the advantage of being easily removable if the work needs to be re-done at a later date. The author prefers, and has successfully used, 'Brummer' stoppings and 'Cryla' texture paste. Both have the advantage of being quick drying. It is useful to be able to fill a hole with a stopping of approximately the same tone as the surrounding paint. 'Brummer' stopping is available in many shades and 'Cryla' Texture Paste may be tinted with any of the 'Cryla' colours to produce a near match to the picture. This pre-colouring will make the final matching easier.

When the original paint is fairly thin and the canvas grain shows through; this texture can be matched by gently pressing a piece of coarse grained canvas into the filler when it is almost dry.

Very wide cracks can occur where the original paint has shrunk. It is generally considered less effective to fill these, and better to 'stipple' paint into the crack to match the surrounding areas (see step 6).

18. Filling holes in the original canvas with acrylic impasto paste after first patching or relining the canvas.

18

Restretching Canvases

Materials

Canvas pliers
Large headed tacks
Piece of thin card
Stretcher pieces (and wedges) of appropriate size
Hammer (small head)

Strictly speaking one should use a pair of canvas pliers to stretch your canvas tightly onto its frame. However if you do not have these, provided you keep an even tension on your canvas from end to end and side to side, tapping the wedges will provide the final stretching.

Place your stretcher frame on the canvas so that the picture area comes to the outside edge of the frame and tack or staple one long edge of the canvas to the side of the frame (illustration 19).

Hold picture and stretcher frame so that the opposite long edge is upright. Pull canvas taut and tack from centre outwards towards each end, tacking at the spot where you have tightened the canvas (illustration 20).

Repeat procedure on the other two sides. The canvas, viewed from the front, should be flat with no 'pulls' where the tacks are placed.

Insert the wedges, place a piece of thin card in the corner between the canvas and stretcher frame and gently tap home the wedges until the canvas is evenly taut. Work on diagonally opposite corners (illustration 21) each time inserting the piece of card before tapping home the wedges.

19. *Tacking the first long edge of the canvas.*

20. *Tacking the opposite long edge.*

21. *Tapping home the wedges to tighten the canvas.*

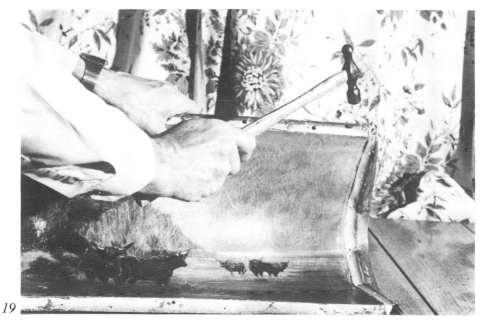

19

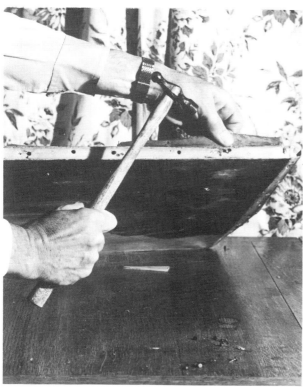

20

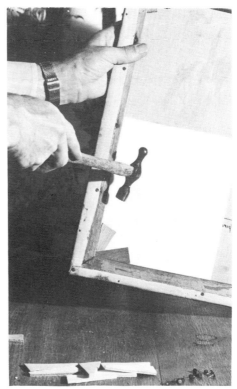

21

Boards and Panels

Materials

Beeswax mixture, pot, brushes as in Step 3
Craft tool or surgical knife with curved blade
Impact glue
Thin paper
Hardboard or plywood (for mounting paintings on cardboard)

Many pictures have been painted on wooden panels or cardboard. Flaking and lifting is much more difficult to rectify here than on canvas as repairs must be done from the painted side. Discreet use can be made of a glue on non valuable paintings, but in general the Beeswax mixture and warm spoon method is recommended.

Wooden panels also suffer from problems of the wood grain opening and splitting. However tedious, the cure is filling and repainting the panel. These cracks or splits should be filled with glue and carefully clamped in order to keep the panel flat until the glue has set. The panel should then be braced with simple glued on struts across and along the back.

Paintings on cardboard suffer, in the main, from bumps which are visible from the front of the picture. These, as against undulations in the board caused by the normal warping of the card, look similar to insect bites on one's skin. They can be rectified by scraping with a sharp curved bladed knife, available from most craft tool shops. Thereby slicing the cardboard away from the **back** of the bump until you are left with only the thinnest skin of card and paint. (They can also sometimes be cured by *mounting down* the complete painting, as described later).

22. It is recommended that supports of the same thickness as the painted panel be used as illustrated. Do not cover the filled cracks with the cross bars and fit these bars and clamps at both ends of the painted panel. If the paint is thick (impasto) a piece of thick and soft material should be placed between the bar and paint surface for protection.

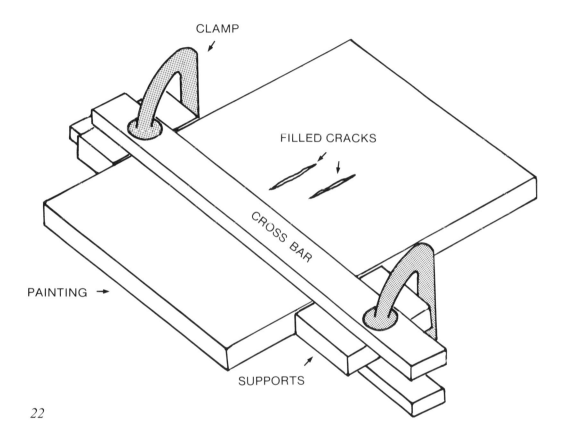

CLAMP

FILLED CRACKS

CROSS BAR

PAINTING

SUPPORTS

22

Place the painting, face down, on a hard surface and fill the scraped out area with a hard setting glue, cover it with thinnish paper and a weight to keep the whole area flat whilst the glue is hardening. When the adhesive has set, glue (the author suggests an impact adhesive with a 'time-setting' period) the cardboard onto a wooden panel of the appropriate size, weighting it down whilst the glue is setting. One is then left with a perfectly flat painting. The mounting in this way of all pictures painted onto cardboard is to be recommended.

23. Crossed struts glued onto the back of a warped panel to straighten and maintain the correct shape.

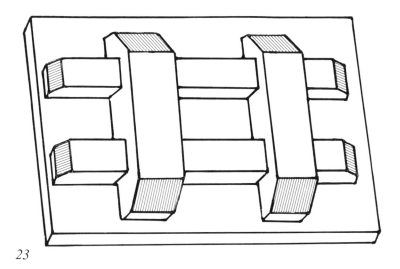

23

Cleaning the Painting

Materials

Table easel
Protective gloves
White spirit
Cotton wool (roll)
Cotton wool (buds)
Picture cleaner (Winsor & Newton)
C.R.P. wax (Roberson)
Scrubbs Cloudy ammonia
Iso-Propyl alcohol
Acetate
Diacetone alcohol
Craft tool knife or surgical knife with curved blade (removal of varnish) pointed blade (for fly spots)
Needle for removal of fly marks
Chlorinate of soda

Cleaning can take place with the canvas in a flat, upright or leaning position. If in an upright position care should be taken to avoid varnish solvents from running down the picture. On smaller paintings a table easel with its conveniently adjustable rake is a good idea for holding the painting.

Remember to use protective gloves.

The first step is to clean any comparatively loose grime from the surface of the picture. White spirit on a pad of cotton wool will do this. The spirit will not affect old varnishes, although it will dissolve modern ones. It will also, for a short while, have the advantage of brightening the picture — just as though it had just been varnished — therefore giving the restorer a glimpse of what may be to come (illustration 25).

24. *The use of protective gloves is essential.*

25. *Removing surface dirt with white spirit or turps.*

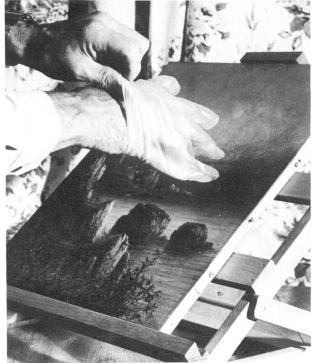

24

25

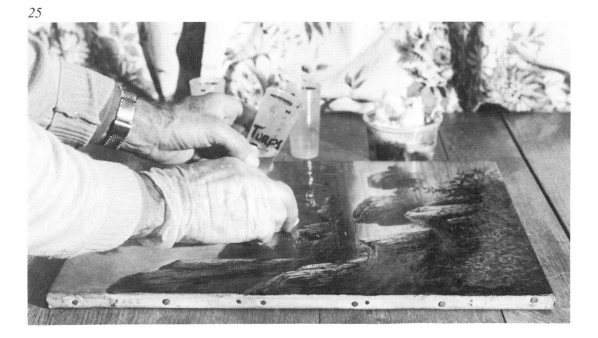

When all the surface dirt has been removed inspect the white or light areas to see if the original varnish has yellowed. If the varnish has discoloured this can also be seen in any areas of blue sky which may have taken on a greenish yellow tinge. If however the varnish is clear then an application of Winsor and Newton's 'Picture Cleaner' will probably suffice and prepare the picture for any re-painting required and the final re-varnishing. Alternatively Robersons C.R.P. wax can be used either to re-vitalise old varnish if no re-painting is required and has additional side benefits such as the removal of 'bloom' and filling of small cracks.

If it has been discovered that the painting has not been varnished properly the surface dirt is likely to be ingrained in the paint. There is little you can do in this case. A light wipe with a 10% solution of Scrubbs Cloudy ammonia may help but it is likely that this process will remove paint as well as dirt and so one should always be ready to stop the process with swabs well soaked in white spirit, drying the area with cotton wool afterwards. The more acceptable alternative is to repaint the lighter areas of the picture using a thin wash of a matching colour, ignoring the darker areas where the imperfection will be less noticeable anyway.

Discoloured (yellowing) varnish is best completely removed. Many chemicals, mixtures and methods are used, according to the type of varnish and the individual restorer's technique. Among those most commonly used are Iso-Propyl Alcohol, Acetate and Diacetone Alcohol, Scrubbs Cloudy Ammonia (diluted) can also be used but with great care because of its severe bleaching properties. These chemicals are mixed together, or used singly, according to their ability to dissolve the old varnish.

Test at a corner and in various parts of the painting with a cotton wool 'bud' and, if the reaction is too severe — removing both varnish and paint, dilute your chemical with white spirit until the mixture softens and removes the varnish without excessive rubbing and without harming the paint. It may be necessary to use different dilutions for various areas of the picture (illustration 26 — enlarged test areas).

26. *Testing the reaction of the varnish to your solvent.*

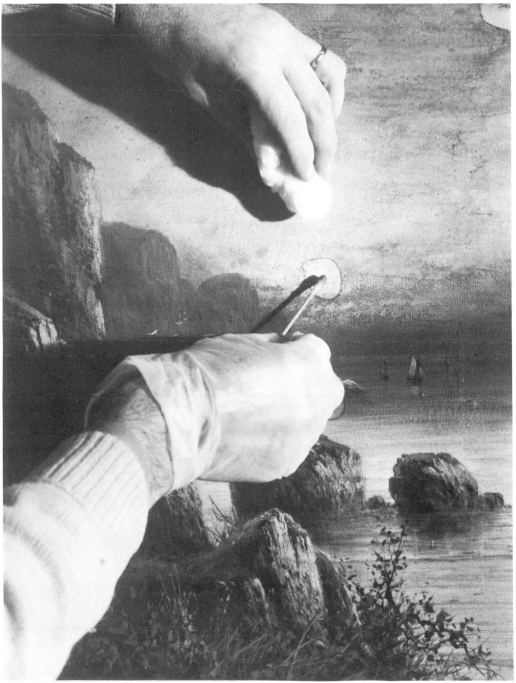

Some colours of paint are softer and more easily removed than others and the chemicals you use, successfully, on a blue sky, may remove some of the less hard browns and greens in the picture. It is therefore inadvisable to move blithely from, say, a sky area to a land area, or indeed from one colour to a completely different one without using a 'bud' and testing the new area first.

Watch your cotton wool swabs for traces of oil paint, as distinct from discoloured varnish, and stop immediately any appears. Have a small container of white spirit and a cotton wool pad ready so that if paint appears on your swab whilst removing the varnish you will be able to immediately stop the chemical's action with some white spirit (illustration 27).

Work on small areas of paint at a time, completing each with a wash of white spirit to remove all traces of the chemical before commencing on the next area (illustration 28).

Where the paint is thick (Impasto) the discoloured varnish will lie thickly on the side or in the crevices. Remove by delicately scraping with a surgical knife or with a cotton wool bud (illustration 29).

27. *Cleaning the painting with a solvent whilst ready to stop the chemical effect with a swab of white spirit.*

28. *Working on small areas of the painting.*

29. *Thick impasto paint requires special attention.*

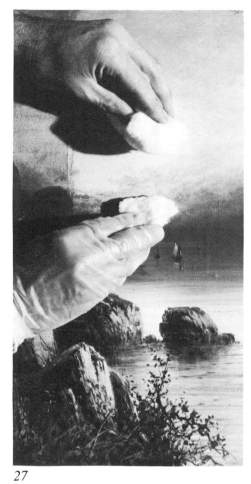

27

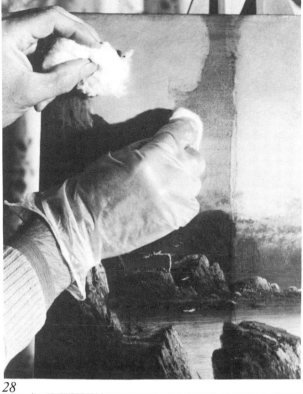

28

29

The artist's signature demands special attention. Often signed with a thinned down paint, the name can sometimes be removed quite easily before you are aware of what is happening. Use care and a cotton wool bud (illustration 30).

Where the picture frame has been removed a lighter edge of the painting will be revealed. If you are re-framing the painting it may be that the rebate of the new frame will not cover this 'imperfection'. Work on the edge with a bud trying to blend the darker looking main area with the fresher edge (illustration 31). If they cannot be matched the edge will need to be re-painted to blend in (see Step 7).

Tears, especially if not yet patched or adhered together, should also be worked on with care, using a bud. If loose paint is apparent, over-enthusiastic applications of liquid will only aggravate the fault (illustration 32).

30. The area covered by the artist's signature should be cleaned with care especially when the signature is thinly painted.

31. Fresher looking paint will be found along the edges of the painting where it has been covered by the frame rebate.

32. Minor flaking can occur along the edges of a tear and therefore cleaning should be carried out carefully and preferably after patching.

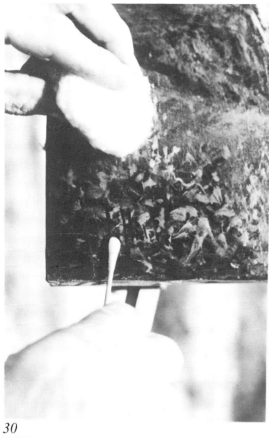

30

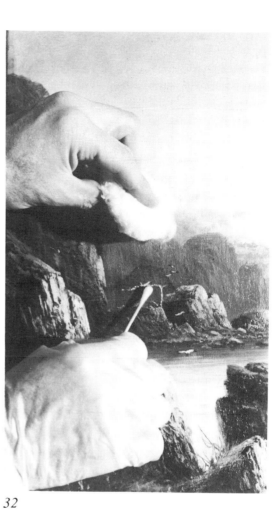

32

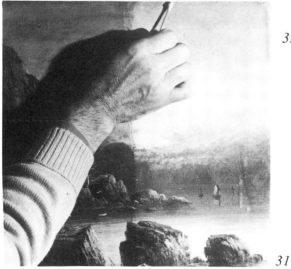

31

Fly Marks

Normally the myriad small black specks on the surface of the picture are the deposits of the house-fly. Fly marks can usually be removed by using the point of a needle or a fine sharp knife blade to prick or spring them off the paint surface (illustration 33).

If a small stain is left a solution of chlorinated soda or cloudy ammonia will remove it (care should be taken that the solution does not bleach the paint colour) leaving the area clear.

When all the cleaning and varnish removing processes have been completed the painting should be given a final 'wash' over with white spirit. When this has dried the next step — re-painting if necessary, and if not, re-varnishing, may be commenced.

It is possible that after cleaning, a white 'bloom' will appear on the surface of the painting. It will normally disappear at the varnishing stage.

Foxing

On oils painted on cardboard panels which have been affected by damp, small brown blemishes may occur which are similar in appearance to the 'foxing' which forms on old watercolours and prints. This usually can be removed by spotting the blemish out using Scrubbs Cloudy ammonia (diluted) on the point of a fine soft haired brush. This may also remove the colour of the paint and retinting will be necessary.

33. *Removing fly marks with the point of a needle*

34. *The 'foxing' effect on a damp cardboard panel.*

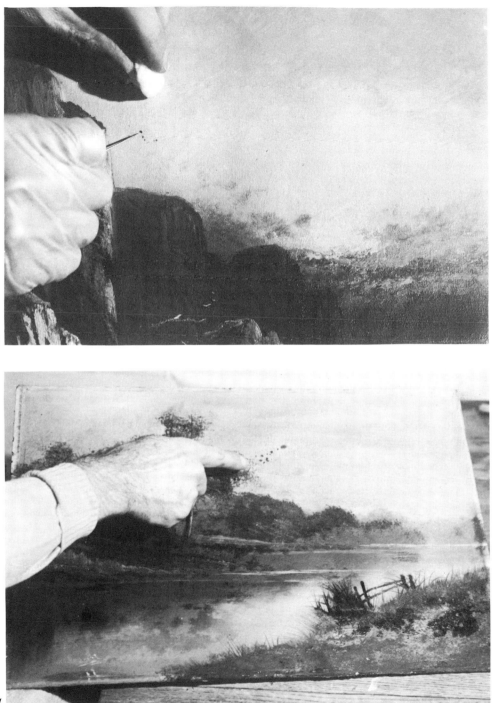

33

34

Re-Painting

Materials

There is a huge range of colours available but most tints can be mixed from a small number of these. A typical selection might be:-

Coeruleum blue
Ultramarine blue
Viridian green
Burnt umber (brown)
Raw sienna (yellowish Brown)
Raw umber
Cadmium yellow
Yellow ochre
Cadmium red
Crimson (alizarin)
White (larger tube than other colours) titanium or underpainting
Black
Tinting saucer (if using watercolours)
Tear off palette
Mixing knife
Brushes:- soft hair, pointed, for stippling
 soft hair, flat, for general brush work
 hog hair, flat, for general brush work where brush
 marks are required
 wide soft hair flat brush for varnishing
Retouching varnish
Turpentine (distilled)

Oil acrylic or water colour paints can be used to re-paint areas on oil paintings, although oil paint, especially the restorers' range mentioned later is preferable.

To make the matching of the fresh paint to the old paint easier, it may be preferable to first apply a thin coat of either re-touching

35. Mixing colours ready for repainting.

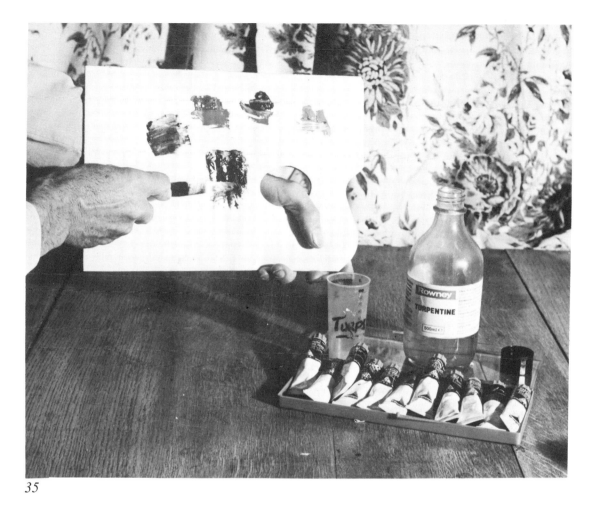

35

varnish or diluted picture varnish (a 60% varnish to 40% white spirit mixture). This will bring out the true colour of the original paint and will make the mixing and matching of the new wet paint more accurate.

The new paint is likely to change colour slightly as it dries. The resultant difference, especially in flat single colour areas such as some skies, may well become even more obvious in the passing of time. It is unlikely that the restorer will coincidently use the same mixture of colours to reproduce a tint that the original artist used, and therefore the pigments in the new paints, especially if student's quality colours are used, could possibly alter drastically in the course of time, making the re-painting quite apparent.

For this reason many restorers prefer not to 'stipple', a dabbing technique with a fine brush, the area of the tear or imperfection but to disguise the problem by covering a larger area perhaps adding a cloud, extending a tree or something similar. Care should be taken in this and other re-painting to observe and match to your best ability the brush work and general technique of the original artist.

Acrylics and water-colours have the advantage of being quick drying but are not always suitable for use when re-painting large areas. Oil paints normally dry slower, more so when white is added to colours to lighten them. However, underpainting white can be used in mixing oil colours and it is quick drying and non-yellowing. Titanium white is the modern equivalent of Flake White. Both are slower drying than underpainting white and Flake White also has a tendency to change colour.

There is available now a range of oilpaints especially made for the restorer, they are quick drying and are made with artist's quality pigments. They are also prone to minimal colour changes both whilst drying and thereafter. (Series R. Restorers Colours).

Having lightly varnished your cleaned oil painting decide on the nearest colour in your range to the one you wish to match. Look closely at the colours the artist has generally used. For instance a touch of a particular red or green somewhere in the painting is a clue to the colour the artist has mixed with the blue in his sky. Observation of the picture at this stage, before mixing your colours, can save time and effort later. Remember that adding white to a colour does not necessarily make it simply a lighter shade of that colour.

36. *Stippling the new paint onto a faulty area.*

50

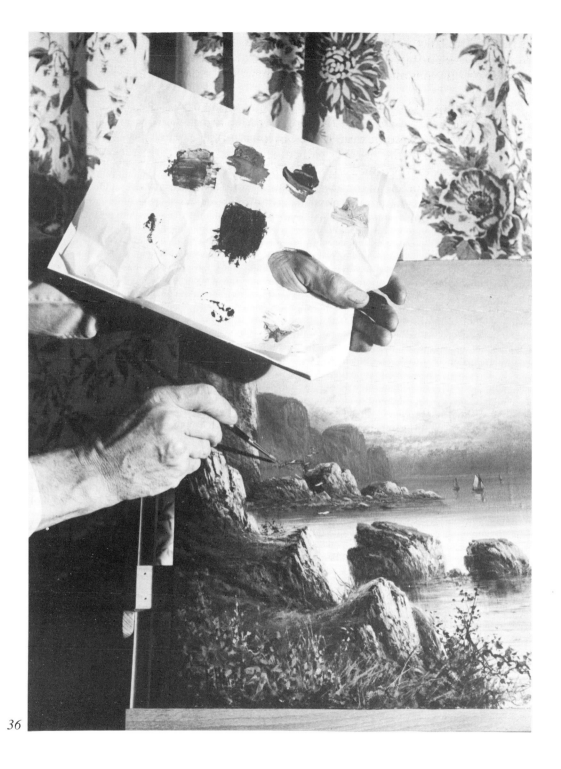

Mix your colours thoroughly in a saucer or on a tear off palette using distilled turpentine as a dilutant to achieve the consistency you require (illustration 35).

Try a tiny amount on the area to be re-painted and view this from several angles, if you are not satisfied with the colour match, add colour or colours to the original mix until you are satisfied, or until you decide to disguise the area with an addition rather than unsuccessfully 'matching' it.

The 'stippling' technique is usually best if covering a small area where you are matching colours, a full brush technique or the use of your fingers might be used on larger areas or 'additions'' (illustrations 36 and 37).

37. Blending new paint with the old paint using the fingers.

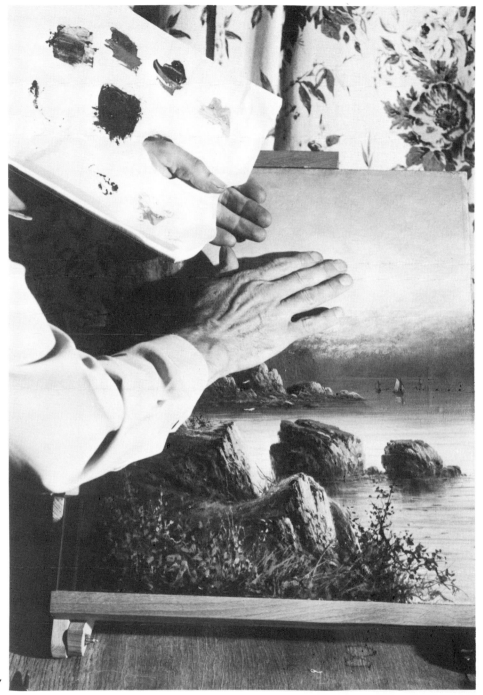

Re - Varnishing

Materials

Wide soft hair flat varnish brush
Retouching varnish
Picture varnish
Matt varnish
Matt wax varnish
Dish or cup in which to hold varnish
Needle (or pointed knife)

By the time your re-painting is dry your picture may well have gathered some dust. Remove this carefully without rubbing the surface of the painting over-hard (a feather duster or ultralight use of a linen rag). Professional restorers can go to extraordinary lengths to produce a dust free environment in which they do their varnishing, and the nearer to this you can get the better will be your results. Check carefully as well for odd strands of cotton wool from your cleaning processes, especially if the painting is impasto.

Spraying the varnish on undoubtedly gives the best results. It would be necessary to use a small spray gun with diluted varnish. An aerosol spray of picture varnish would not always be advisable as the varnish is very thin and the solvent in it may have an adverse effect on the recently painted areas.

There are three basic varnishes: **Retouching Varnish** is a thinner version of picture varnish and is suitable where a not too glossy (between silk and high gloss) finish is required. It does not give as much protection as picture varnish and two coats would probably be required. **Picture Varnish** imparts a high gloss, which can be reduced a little by means of a sparing application and by working it into the picture thoroughly. **Matt Varnish**: both previous varnishes appear to bring out the colours in a painting. Matt varnish, used by itself, does not. It is mainly and most effectively used mixed with the

38. Almost any dish will do for your varnish.

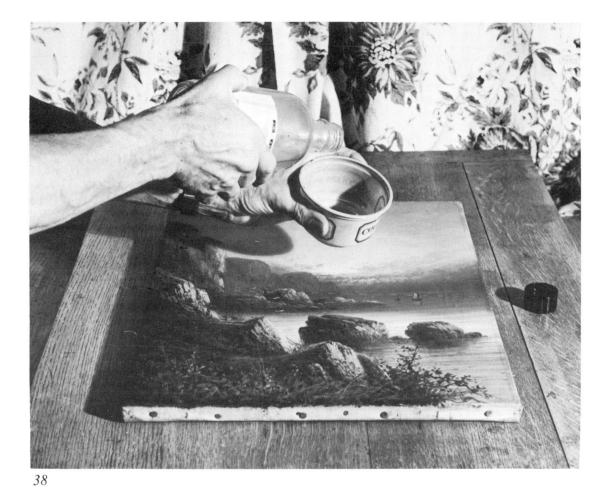

38

glossy varnishes to produce an eggshell or semi glossy finish which affords full protection to the painting.

The technique of varnishing is simple. Use a wide, soft hair brush, which you have flirted to remove loose hairs. Ensure that one's clothing is not of the type that deposits hairs or fluff into the atmosphere and thus onto the painting and preferably work in a warm room. Lie the painting flat and pour a quantity of the chosen varnish into a dish (illustration 38).

Remember that unless your re-painting is thoroughly dry, too much pressure on the brush or use of the re-touching varnishes, which contain a thinner, may result in removal in part or whole of your work. Apply the varnish to the painting, working it in well, finishing with light strokes along and then across the surface (illustration 39). Watch out for hairs or fluff that appear as you are varnishing and remove them immediately. A needle or pointed knife blade is a useful implement for this (illustration 40).

When completely dry apply a second coat if necessary. If at this stage the varnish is considered too glossy, or simply a more matt surface is required, the next coat could either be a matt/glossy varnish mixture or a matt wax varnish.

39. *After applying the varnish firmly a light stroke of the brush across the surface will produce an even coating.*

40. *Watch carefully for loose hairs from your brush and other foreign particles. These should be removed while the varnish is still wet.*

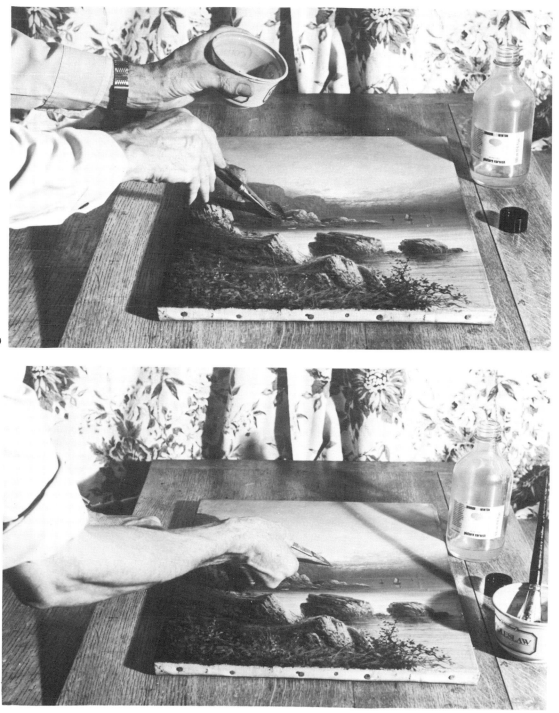

39

40

Selecting Paintings for Restoration

Now you have some idea of how to clean and restore oil paintings. However at this stage it is perhaps a good idea, to repeat certain statements made during the preceding text before proceeding.

Certainly too great an emphasis cannot be made of the fact that the procedures explained to you in the text of this book are in general, basics, and the keen restorer will experiment with them, combine and mix the solvents to suit varying requirements, and carefully — very carefully — try out new ones. In short build upon the knowledge contained in this volume.

In particular one should bear in mind that EXPERIENCE COUNTS. Learn from every painting you work on and start off with the realisation that every painting will be wholly, or partly, different. Each artist has his own technique, personal tricks and short-cuts so that the end product will therefore be likely to react in varying ways to your own techniques and materials.

Having cleaned the old painting you have discovered in the attic (first having made sure that it is of little value), you are, hopefully, pleased with the result and will want more paintings to practice on. This chapter is aimed at giving you some general guidelines on how to choose the paintings which are reasonably easy to deal with and where the problems are likely to be minor rather than major. However, easy-to-clean paintings are not always easy-to-buy paintings and good quality pictures, which are often easiest to restore, are normally recognised as such by the seller and are priced accordingly.

41. This painting has been crudely overpainted in the sky area at the top right hand corner. The restorer would remove this and deal with any imperfection he finds properly.

41

Where to find paintings

The most obvious way to find suitable pictures is to ask your friends and relations if they have any old oil paintings, however bad the condition, on which you can practice your hobby. This is also useful for when the work is restored and has a clean coat of varnish on, you can present the astonished owner with proof of your newly found expertise. Jumble sales can also be a good source of supply as can church and missionary sales and any other sales sponsored by charities and youth organisations.

Auction rooms are an obvious source of antique paintings. It is here however that one must be aware of the value of the painting before becoming involved in the bidding. Paintings may look to be in extremely poor condition and, to the inexperienced eye, appear to be of little value, but this is not necessarily the case.

The first step is to look at the pre-sale estimates. Normally two figures will be shown within which the painting is expected to sell. These prices, however expertly set, are intended only as a guideline and can sometimes be exceeded if there are two very keen bidders. However considerable time can be saved by using these estimates and not examining those paintings which will be too expensive.

When you find a painting that you like and which appears suitable for you to restore, if it is likely to be within the price range you can afford, then mark it in your catalogue and decide on a ceiling price which you will not exceed. This way it is quite possible to find the painting which you want at a modest price because most dealers are likely to be buying the better quality works.

While it is possible to buy suitable paintings at antique shops and antique fairs there is a tendency to over-price, so one must be particularly careful about purchasing from either of these. In antique shops even badly damaged paintings of no particular quality can be expensive, as the sellers either consider that age equals high price, or 'they know how good a particular painting will look when restored'.

Antique fairs rarely have good paintings, inexpensive or otherwise, and one again gets the impression from the prices that the prospective purchasers are not expected to know very much about either values or paintings. The author has, for instance, been offered "watercolours" which were clearly prints; when this was pointed out

42. The picture auction room at Christies South Kensington.

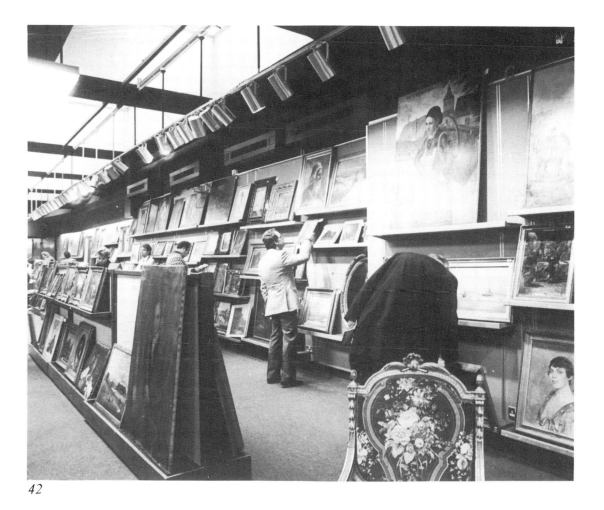

42

the seller appeared quite astonished but it was noticed that the item was still on offer as a "watercolour" later in the day. Stories of this nature are numerous and whilst the majority of dealers are honest —buyer beware!

What to look for

In the early stages of learning restoration there are some problems which are best avoided. Later on you may wish to take on all types of work in order to gain experience but you should be aware at least of the following faults:

Thinly painted: When the texture of the canvas is very obvious through the paint. Where background detail can be seen through foreground paint. Where there are small areas —usually of background which appear unpainted. Such paintings are very difficult to clean and are best avoided at least in the early stages of learning restoration.

Badly flaking paint: This is self explanatory. Whilst dealing with flaking has been explained, it would be very arduous for the purpose of practise, to have to treat an entire picture. This should also be born in mind if excessively wide or fine cracking is apparent.

Dry canvas: If the canvas feels dry to the touch (feeling the back of the picture). Place your ear to the painted side and run your fingers, pressing lightly, over the back of the canvas. If you can hear a faint "crackling" it will mean that the picture will probably need to be completely re-lined as the paint is beginning to lift off of the canvas. Unless, therefore, the painting is quite good and has few other faults it is unlikely to be valuable enough to spend money on a re-line.

43. *Illustration of thin foreground paint with background showing through.*
44. *An example of flaking paint.*

43

44

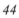

Stretchers: Look for broken corners and wood-worm. If the stretchers suffer from either of these they will need to be re-placed. This can easily be done if the canvas is of standard size as most of the art suppliers listed in this book can supply stretchers in a whole range of ready made sizes at very reasonable prices. The size of stretchers increase in one, sometimes two inch measurements but they are not available in parts of an inch. If the canvas is an odd size, one must consider if it will reduce down to a standard stretcher size without a detrimental loss of picture area. If this is not possible then most picture liners will be able to have stretchers made up to the size you require, but these are naturally more expensive than standard sizes.

Dampness: If the canvas or cardboard on which the picture is painted is — or clearly has been — damp then there is a distinct chance that a reaction is in progress where mould or flaking paint may occur at a later date. Where damp has occurred small brown blemishes similar to the 'foxing' on an old watercolour may sometimes appear. (see page 46) It might be as well to avoid any such paintings entirely.

Varnishing: The quality, evenness, or even lack of varnish can be seen by tilting a painting to catch the light and thus reflect the sheen of the varnish. If this is patchy then attention should be paid to the unvarnished areas. Very thin paint in any such area would be difficult to clean. Thicker paint would be unlikely to cause problems. A good even coat of varnish albeit on a thinly painted picture would make even that painting a more practical one to buy.

Remember that the foregoing is not written to help you find a valuable picture, which is another thing entirely, but to aid you in selecting paintings which should not present you with too many problems.

45. *Listening for the crackling of paint lifting off a dry canvas.*
46. *Typical example of stretchers broken at the corner.*

45

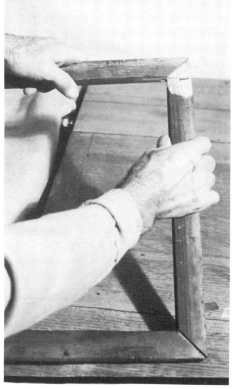

46

Restoring Old Frames

Many old pictures will come with equally old frames. The cost of re-framing in an equivalently wide and ornate frame today may well be more than the picture itself is worth or anyway more than one is willing to pay. The alternative is to restore the original frame to an acceptable condition.

The art of picture frame restoration and re-gilding would make a book in itself and few picture restorers have either the time or the knowledge to turn out a first-rate professional job.

None the less it is quite possible for the amateur to restore old frames to a good standard by using comparatively simple methods and easily available materials. Examine the frame. If it is carved wood it is valuable and should not be tampered with except by an expert. Most frames however are made of plaster on a wooden base and these quite often have pieces of plaster missing or loose.

Step one: The first thing the restorer should do is to carefully remove any loose pieces of moulding. Ensure that all particles of dust and dirt are cleaned away from both the frame and each detached piece of moulding. These pieces can then be glued back into position together with any other detached pieces, using a P.V.A. wood glue. Whilst the glue is setting the piece must be firmly held in position. Sellotape or elastic bands may be used for this purpose. Check the position of the piece of moulding after it has been fastened onto the frame. If it is a long piece it is best to fasten it at both ends and the middle. See illustration 49 for the method of holding elastic bands onto the frame.

47. *A selection of unrestored frames.*

48. *Refixing loose pieces of moulding.*

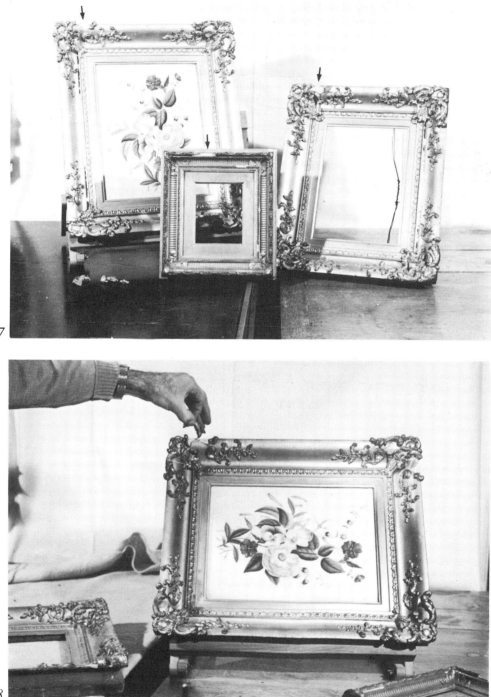

47

48

Step two:
Small missing areas of moulding will almost always be replaced by filling the gap with Barbola paste, or with one of the other materials mentioned later. Barbola paste has the advantages of drying quickly, minimal shrinking properties and the ability to produce a fine surface with the application of a wet blade. It can also be shaped to near its final design with a wet knife. When it is dry and hard it is possible to work on the final shaping with a scapel or craft tool blade, (illustration 51).

49. Securing reglued or new moulding in position with an elastic band.

50. Filling a small gap with barbola paste.

51. Use a knife or sandpaper to shape the hard barbola paste into its final design.

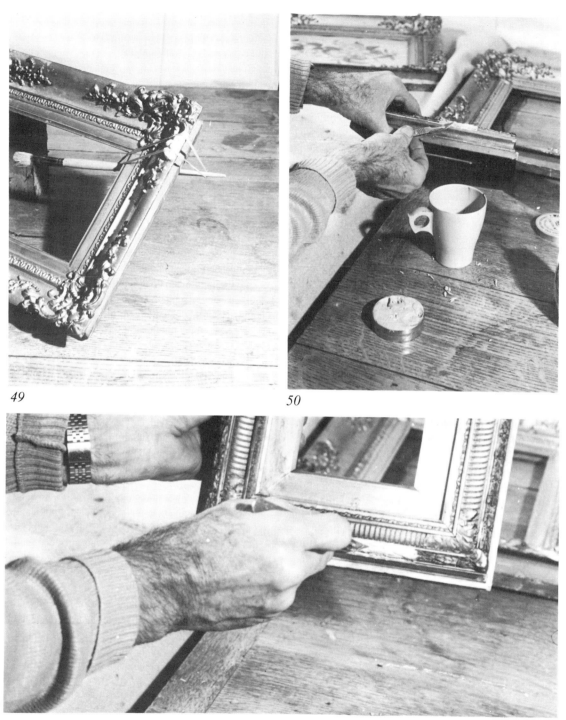

49

50

51

Step Three: There are several alternative methods of replacing larger missing areas of plaster. Most professionals will make a mould from a perfect piece of the frame using plasticine.

Firstly, smear the good piece of moulding with a light coating of grease — such as vaseline — in order to facilitate later removal of the plasticine cast. Next warm the plasticine by working it between the hands until malleable. Press it firmly onto the area to be cast covering an area of approximately 25% extra at each end. The plasticine should be at least 1″ thick over the part to be copied. It should then be left for several hours in a cool place until comparatively hard to the touch (illustration 52).

The plasticine mould may now be removed. Use considerable care at this stage as a mould distorted by careless handling will necessitate starting all over again. Lightly grease the inside of the mould by applying oil with a small paint brush. It is usual to use a pointed brush for the small areas which are difficult to reach and a small flat brush for larger areas.

Finally, the mould can be filled with a fairly thin mixture of plaster of Paris (about the consistency of cream). As an alternative one can use the powder type of Polyfilla or similar material. When the plaster is hard ease the plasticine mould away from the casting.

The casting can now be trimmed to fit the gap and glued into position.

Check now for any irregularities or gaps and make these good either by shaping with a blade or filling with additional plaster.

52. *The plasticine mould hardening on the frame.*

53. *Removing the plasticine mould.*

54. *The plaster casting being removed from the mould.*

55. *Shaping the casting before glueing into position.*

70

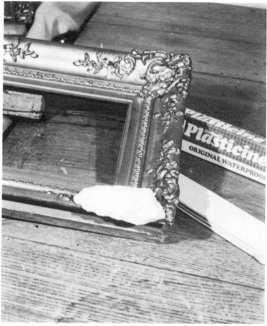

52

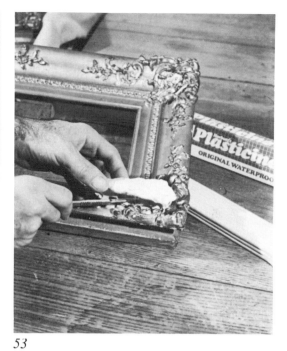

53

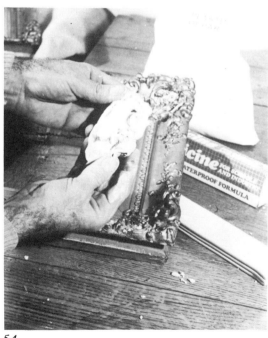

54

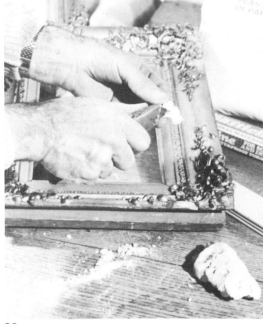

55

Step Four: There may be occasions when it is either impractical or unnecessary to cast replacement pieces of moulding. This is likely to be when the missing pieces of frame are of a simple design.

If the area to be filled is fairly large it will probably help if you can provide a "key" to which the filler can adhere. A few fine panel pins will suffice. (illustration 56).

In this case the missing parts can be replaced by working a suitable material — such as Brummer stopping, plastic wood or a thick mix of plaster — directly into the missing area. Bear in mind that many such fillers, especially those mixed with water, will shrink during drying and you should therefore make an allowance for this. Mould the filler into the rough shape required whilst wet, carve or scrape the design with a sharp blade and finish with a fine sandpaper when througly dry (illustration 57). When your fillers have set solid and are completely dry and shaped, seal them with a thin film of paste or glue; the P.V.A. wood glue — slightly diluted — can be used. This will prevent the colouring which you will apply later from soaking into the filler. (illustration 58).

56. *'Key' pins in position in frame.*

57. *Shaping the filler into its final design.*

58. *Diluted P.V.A. glue used to seal the filler before gilding.*

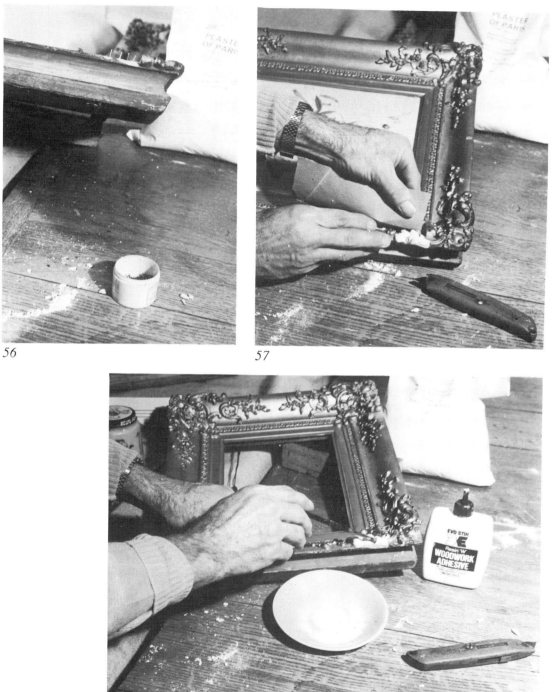

56

57

58

Step 5: Assuming for the sake of this exercise that the frame was originally a gold colour, you will probably find that you will have to re-gild the entire frame, as it is unlikely that you will be able to find a gold colour to exactly match the original gold of the frame.

Your first step will be to clean all dirt and grease off of the frame. White spirit, carefully worked in with a paint brush on the more ornate frames, should be used. Allow the white spirit to dry completely before continuing. Then with great care apply a coating of a liquid or paste gilding paint. 'Treasure Gold' or 'Goldfinger', which are available in many shades of gold, may be used. Ensure that the coatings are as even as possible and if it is required apply a second coat over the first. When these are dry a light buffing with a soft rag will impart a good lustre. (illustration 61).

59. *Cleaning grease and dirt off the frame with white spirit.*

60. *Applying a wax gilding paste to the frame.*

61. *The finished restored and regilded frame.*

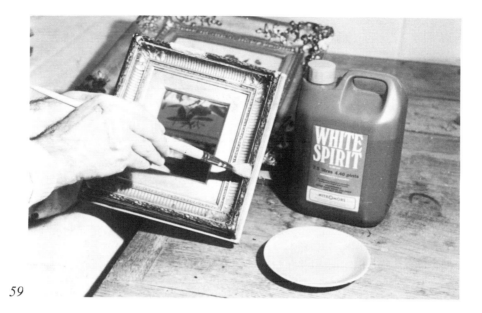

59

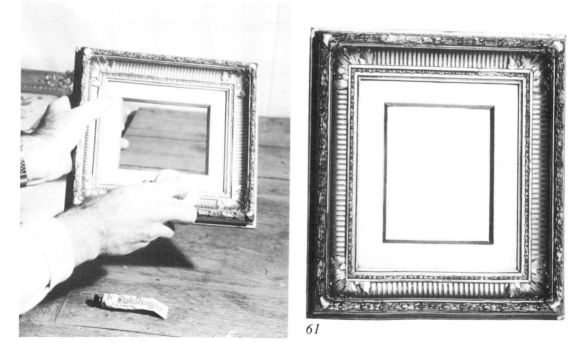

60

61

Glossary

Acrylic Paints: A water mixable, polymer resin based paint. Quick drying.

Artists Quality Paints: Paint which contains genuine pigments and in which the colour is therefore generally more permanent and has good handling properties. This grade of paint is available in oil, acrylic and water colour.

Bloom: A 'cloudy' effect that sometimes appears, or is on the varnish of oil paintings. Probably caused by moisture on the paint or in the varnish.

Brush Strokes: The direction, degree of coarseness and other techniques used by an artist when applying the paint.

Bubbling: Where the paint and/or primer has risen away from the canvas without cracking.

Bud (Cotton Wool): A small stick usually with, a solid wad of cotton wool on each end.

Colour Matching: A particular type of fluorescent tube giving a light which does not alter colours. There are several makes of tube that have this advantage and which may be called by other names. Consult your electrical specialist.

Cracking: Known as 'craquelure', this crazing is now considered to be synonymous with antique paintings and, providing it is not too offensive, does not need to be treated unless the paint is lifting (see under 'Lifting')

Filling In: The filling of a hole or crack to make it even with the original, surrounding surface.

Flaking: Portions of paint peeling or falling off the painting.

Flirt (Flirting): A brisk slapping motion with the tip of a brush's bristles across the edge of one's hand. It brings loose hairs away from the rest so that you can pull them out.

	soft brushes such as those used for varnishing.
Impasto:	Paint put onto the canvas thickly. Sometimes a whole painting will be in this technique, alternatively it may be used only on certain parts of the picture.
Lifting	Where along the edges of a crack, the paint has risen away from the canvas.
Mixing Knife:	A flexible bladed knife ideal for mixing paints. Can be used for both oils and acrylic.
Oil Paints:	Made with colour pigments plus additional mediums such as linseed oil etc. Pigments react in many ways dependent upon conditions and being mixed with other colours and it is useful to consult the maker's information sheet. Oils are commonly mixable with turpentine or linseed oil to provide a thinner consistency, the former being the quickest drying.
Painting Knife:	A flexible bladed knife, preferably with a cranked handle, for applying paint both finely and in the impasto technique.
Patch:	A piece of new canvas, waxbonded over a tear or hole in an original canvas.
Pigments:	Usually in a powder form produced by various processes including fine grinding. The pigment is then added to various oils water or resins to form a particular type of paint.
Re-Lining:	New canvas bonded to, and completely covering the back of an original canvas. Used where there is considerable cracking, flaking or many holes.
Re-Painting:	The application of new paint onto an old canvas, matching the original colour and technique.
Solvents:	Substances which, singly or mixed together, put varnish into a condition in which it can be more easily removed.
Spotting:	Applying a solvent to a small area with the point of a fine soft brush using a dabbing motion.

Stippling:	Applying paint to a given area by brush in a dabbing movement, touching only the brushes point to the surface of the painting.
Stretcher Frame:	Wooden struts, interlocking at the corners, onto which a painting on canvas can be fastened and pulled taut. (See 'wedges' below).
Students Quality Paints:	Oil, acrylic and water colour paints made with synthetic pigments and in a method of production normally inferior to artists quality paints. They are therefore usually much less expensive.
Swab:	A lump or wad of cotton wool for applying white spirit or chemicals in larger quantities than 'buds'.
Tear off Palette:	A quantity of sheets of greaseproof paper with a thumb hole for easy handling and mounted on a backing board, for mixing oil or acrylic paints.
Tinting Saucer:	A plastic or china 'saucer' with several divisions, ideal for mixing oil or acrylic paints.
Varnish:	A clear film (usually a resin base) used to protect oil paintings.
Wash:	A very diluted, or thinned down, colour.
Wedges:	Wedge shaped pieces of wood which fit into the gaps provided in the inside edges of the stretcher frame (2 per corner) and which, when gently tapped in, enlarge the frame and thus tighten the canvas.

Suppliers

X denotes manufacturer or importer from whom lists of stockists will be available

X Winsor & Newton
Whitefriars Avenue,
Wealdstone,
Harrow, Middlesex,
HA3 5RH
Tel: 01–427 4343

Oil Paints
Watercolour paints
Brushes
Palette knives
Painting knives
Tear off palettes
Tinting saucers
Varnishes
Turpentine (Distilled)
Table easel
Picture cleaner
'Treasure Gold'
'Barbola'

X George Rowney
 & Sons Ltd
P.O. Box 10,
Bracknell, Berkshire

Oil Paints
Water colour paints
Cryla paint
Cryla texture paint
Turpentine
Brushes
Palette knife
Painting knives
'Goldfinger'
Plasticine

X Roberson
71 Parkway,
Camden Town,
London, NW1 7QJ
Tel: 01–485 1163

C.P.R. wax
Beeswax
Dammar resin
Venice turpentine

Maimeri Artists Materials Ltd.
Hartle Bury Trading Estate,
Hartlebury,
Nr. Kidderminster,
Worcestershire DY10 4JB

Series R Restorers paints

Most good Hardware/
 D.I.Y Shops

Brummer stopping
Craft knives
White spirit
Plastic wood
P.V.A. glue
Craft tools

Most chemists

Cotton wool (rolls & buds)
Solvents (usually to order)
Scrubbs cloudy ammonia
Plaster of Paris

Professional Artists Services
60 Mulgrave Road,
Sutton, Surrey SM2 6LX

Suppliers of all items as
 recommended
From:- Winsor & Newton
 Rowney
 Roberson
 Maimeri

(Send SAE for price lists)

Surgical knives/blades
Craft tool knives/blades